My Style

I love creating intricate black and white floral designs that start with foc
inspirational quotes, or mandalas. I always begin with a subject in mind,
the background. Some of my pieces are inspired by famous buildings around the world, and others are
works of fantasy-inspired doodle art featuring forests, parks, waterfalls, etc. And I can't get enough of
bold and bright colors on my drawings!

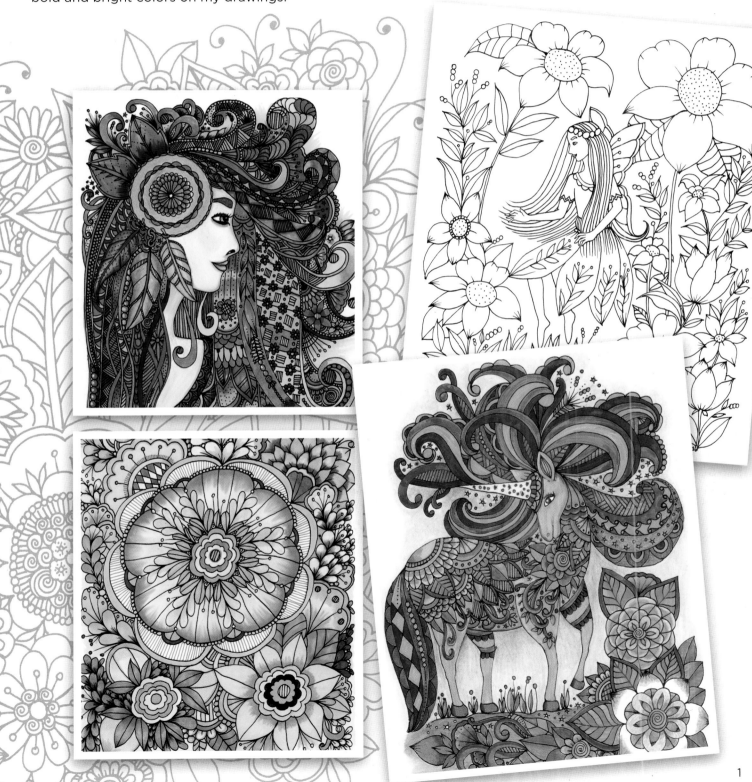

My Favorite Coloring Supplies

Here's a quick look at some of my preferred coloring media. But don't forget! You can also use crayons, water-based markers, gel pens . . . anything you like!

- **Fine-point felt-tip pens:** Some of us love adding patterns on drawings while coloring; felt-tip pens are great for that. They are also good for adding colors inside small, detailed areas.

- **Colored pencils:** For a smooth coloring experience, I highly recommend colored pencils. They are very easy to blend and great for layering colors.

- **Brush markers:** These are your best choice if you want to achieve bright and vivid colors. Depending on the brand that you use, they are very blendable. My favorites are Winsor & Newton and Copic Sketch markers.

- **Chisel-tip markers:** These are good for coloring large areas. With the various angles of the tip, you can get three types of stroke: broad, medium, and thin. Colorless chisel-tip markers are also great to use as a blending tool.

- **Water-soluble pastels:** If you want to add a splash of watercolor to your designs, use water-soluble pastels. They act like crayons when dry, but you have the option of applying water to add a watercolor wash to your work, and they are very easy to manipulate. You can even use an alcohol-based blender pen or a paper blending stump to blend the colors.

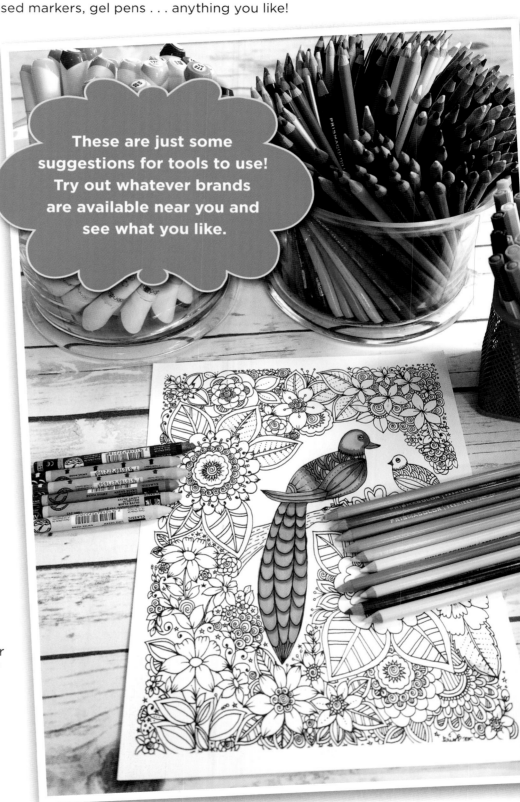

These are just some suggestions for tools to use! Try out whatever brands are available near you and see what you like.

Coloring Tips

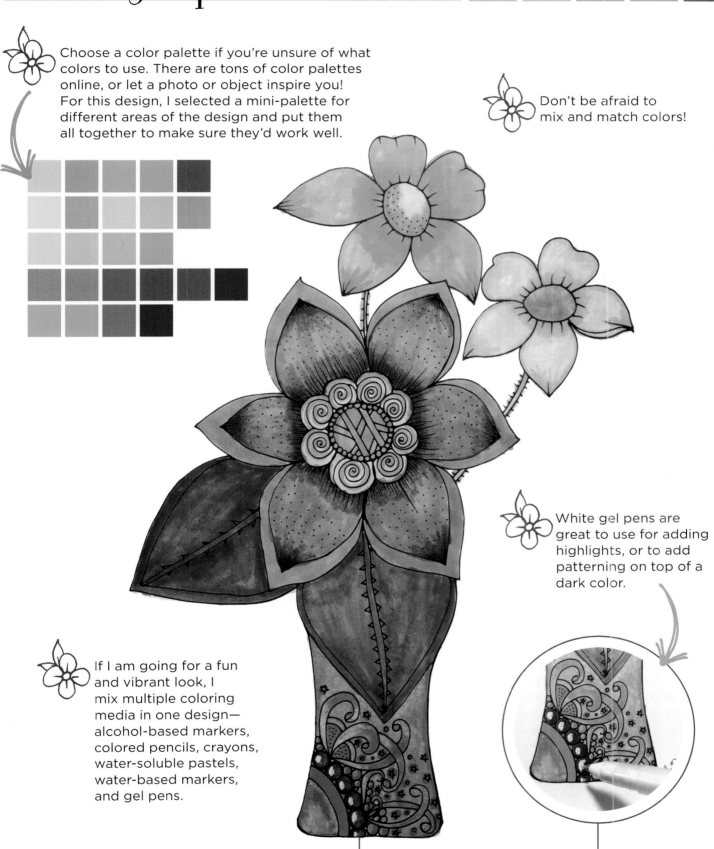

Choose a color palette if you're unsure of what colors to use. There are tons of color palettes online, or let a photo or object inspire you! For this design, I selected a mini-palette for different areas of the design and put them all together to make sure they'd work well.

Don't be afraid to mix and match colors!

White gel pens are great to use for adding highlights, or to add patterning on top of a dark color.

If I am going for a fun and vibrant look, I mix multiple coloring media in one design—alcohol-based markers, colored pencils, crayons, water-soluble pastels, water-based markers, and gel pens.

How to Blend

I'm always going for the well-blended look. To achieve this, I use a good blender, though you can also blend without a blender by simply using several different shades of a single color and building up a gradient with them. But I like to use an **alcohol-based blender marker** with almost every coloring medium and design that I do. Blenders with chiseled tips are my favorite because they are versatile—you can get thick and thin lines and blends out of them. I usually begin with light pastel shades no matter what medium I'm using. That way I can slowly build the colors to bright, bold tones.

1. Fill the center of the flower with a light color, like this yellow.

2. Now use a darker color to go around the inner edges of the flower center, on top of the light color.

3. Blend the colors using a blending tool such as a blending marker, using gentle strokes and moving your tool from dark to light.

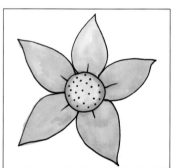

4. Fill in the petals with a new light color, like this orange.

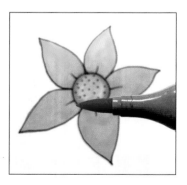

5. Now use a darker color, like this dark orange, around the outer edges of the center of the flower.

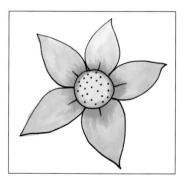

6. This darker color at the base of the petals gives the flower dimensional, realistic "shadows."

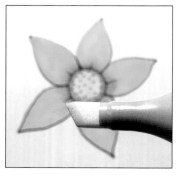

7. Blend the colors using a blending tool such as a blending marker—chisel tips like this one are my favorite.

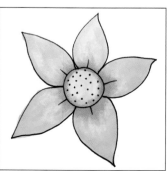

8. Your beautifully blended flower is done!

Coloring Leaves

When I color leafy drawings, I use many different shades of green. I also like to use two different color supplies: alcohol-based markers and colored pencils. Below, I'll walk you through my leaf process! Here are the two color palettes I used in this example.

Alcohol-based markers *Colored pencils*

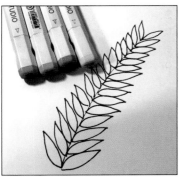

1. Pick the shades of green that you want to use.

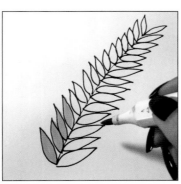

2. Start coloring with the lightest marker.

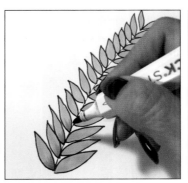

3. Pick a darker marker and begin coloring the corners of the leaves.

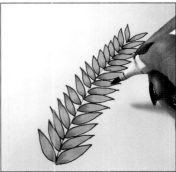

4. Fill in the outer corners of the leaves with the darker shade.

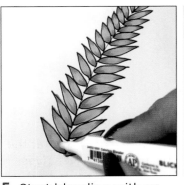

5. Start blending with an alcohol-based blender marker until the light and dark colors are nicely merged.

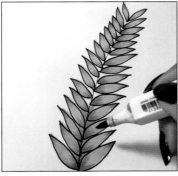

6. Color the stem or stem area with another darker green marker.

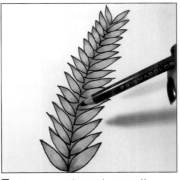

7. Use a colored pencil to add more depth to the leaves.

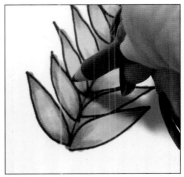

8. Begin tracing the outer edges of the leaves and stem with colored pencil.

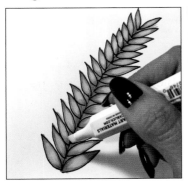

9. Blend everything with the blender marker.

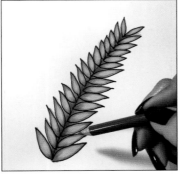

10. Now use a different, blue-green colored pencil around each leaf and stem.

11. Continue with the new color and blend until you're satisfied.

12. You're done!

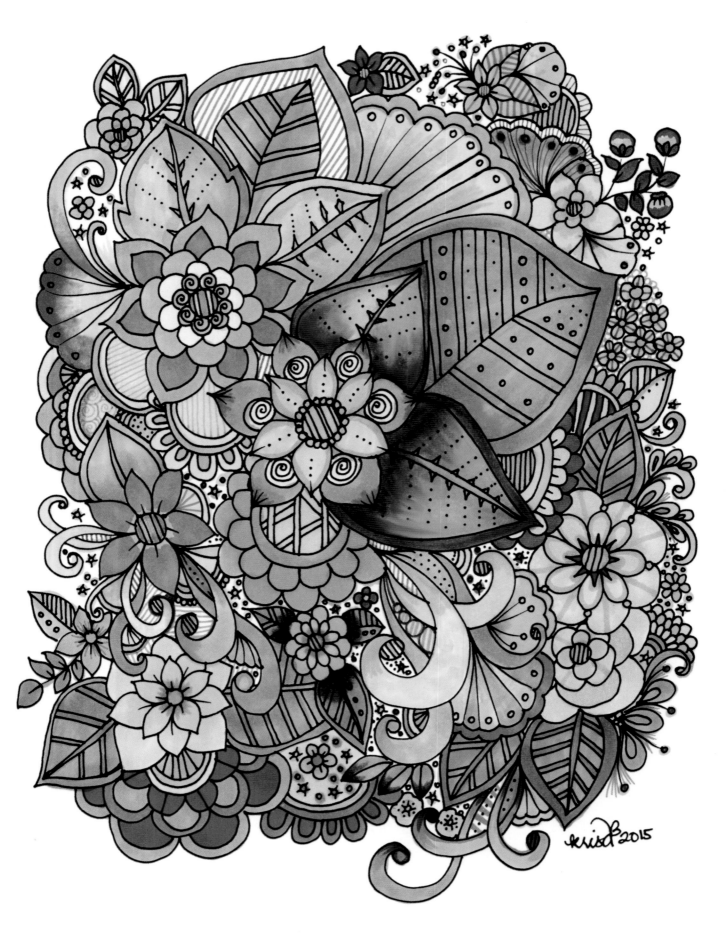

Summer Blooms, page 33.

6 *Markers (Blick, Stabilo). Color by Krisa Bousquet.*

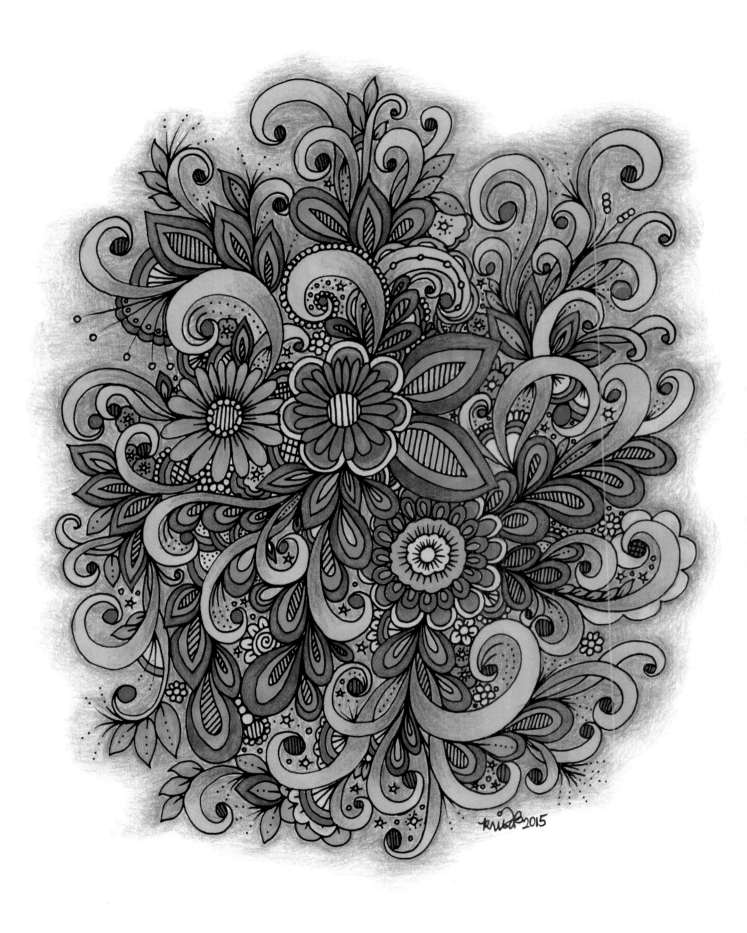

Petal Explosion, page 35.
Markers, colored pencils. Color by Katja Lahti.

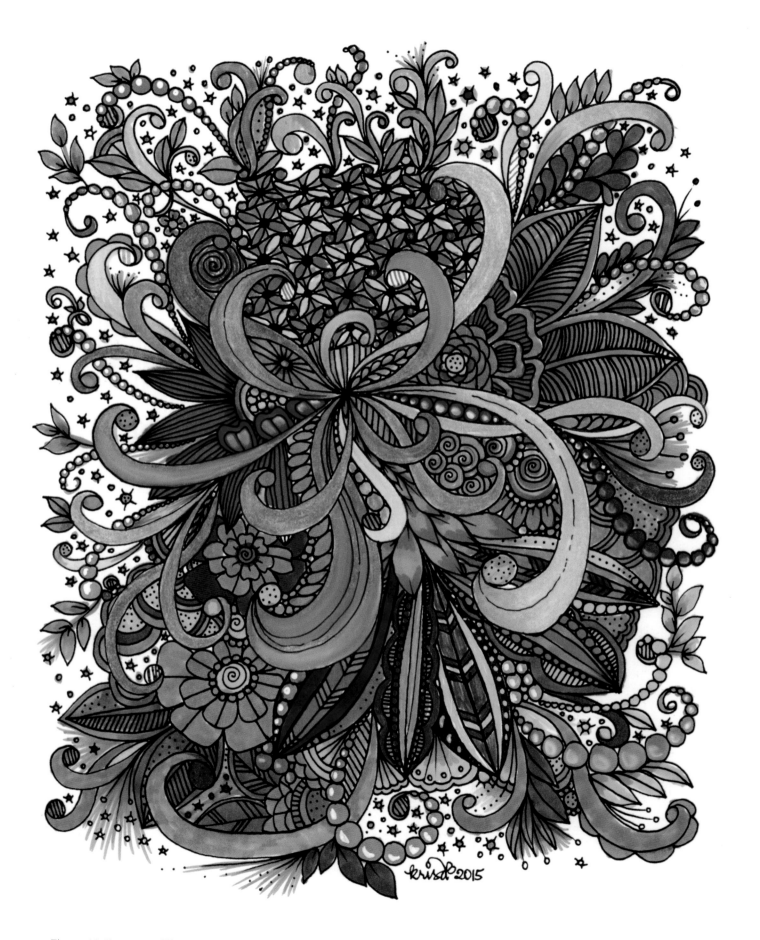

Flower Motion, page 37.

Markers (Conda, Blick, Stabilo), colored pencils (Prismacolor). Color by Krisa Bousquet.

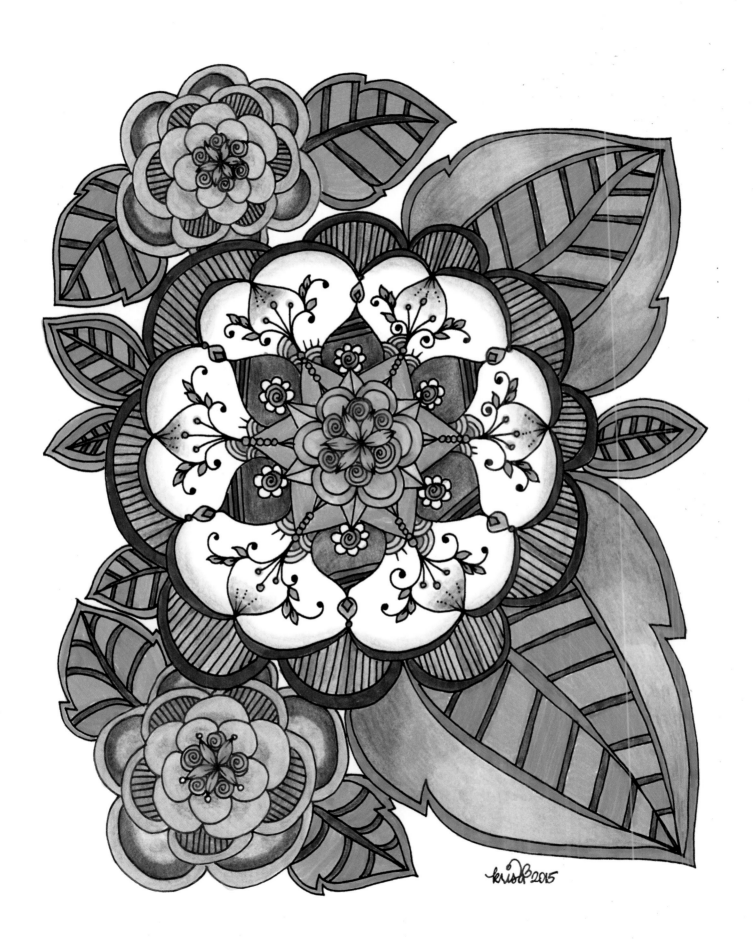

Flower Trio, page 39.
Watercolor pencils, markers, colored pencils (Prismacolor). Color by Darla Tjelmeland. 9

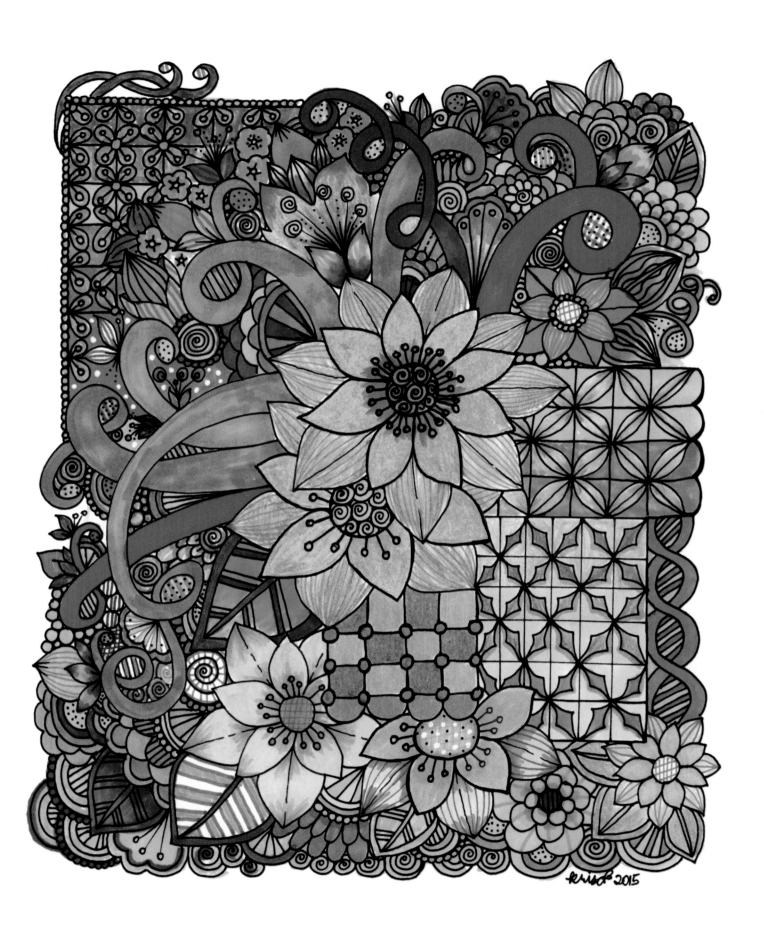

Garden Design, page 41.

Markers (Copic, Conda, Stabilo). Color by Krisa Bousquet.

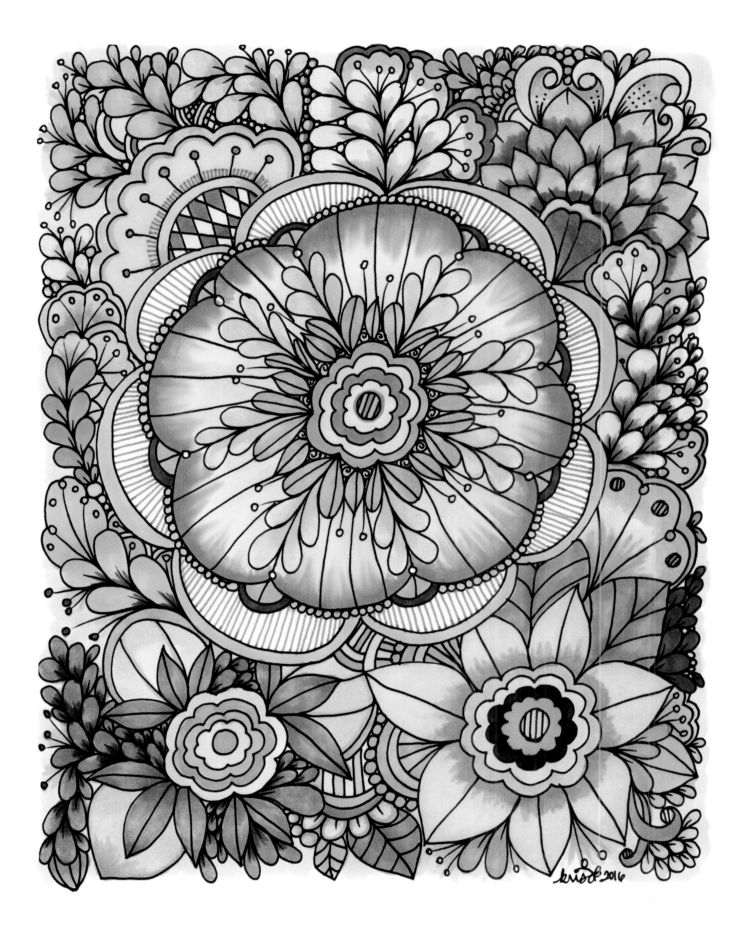

Backyard Blooms, page 43.
Markers (Copic). Color by Krisa Bousquet. 11

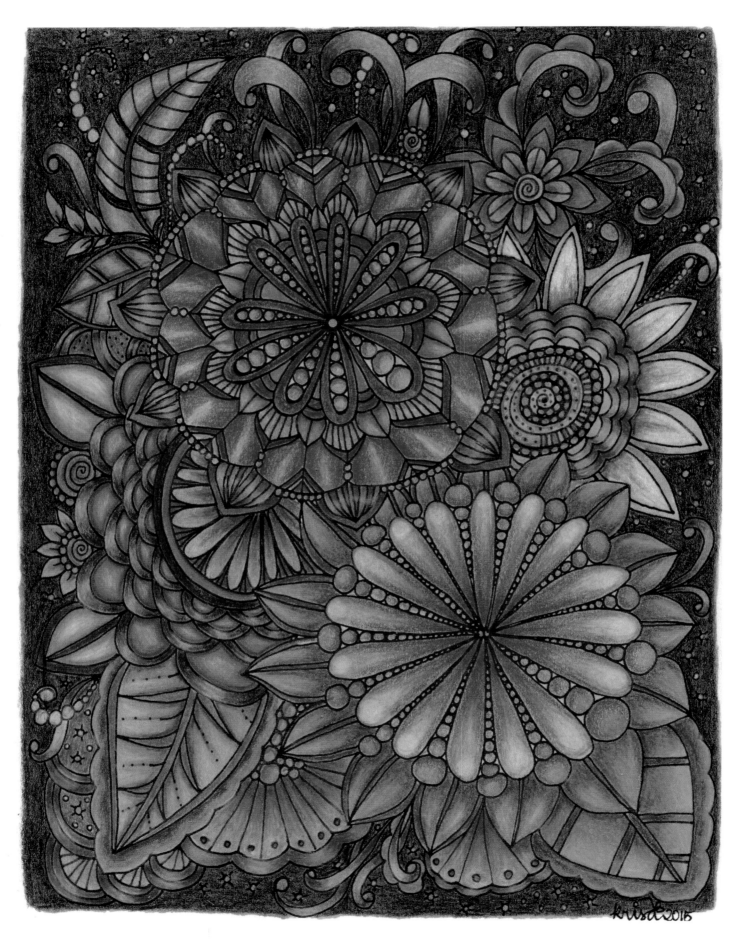

Flower Parade, page 45.

Markers (Letraset), colored pencils (Faber-Castell). Color by Katja Lahti.

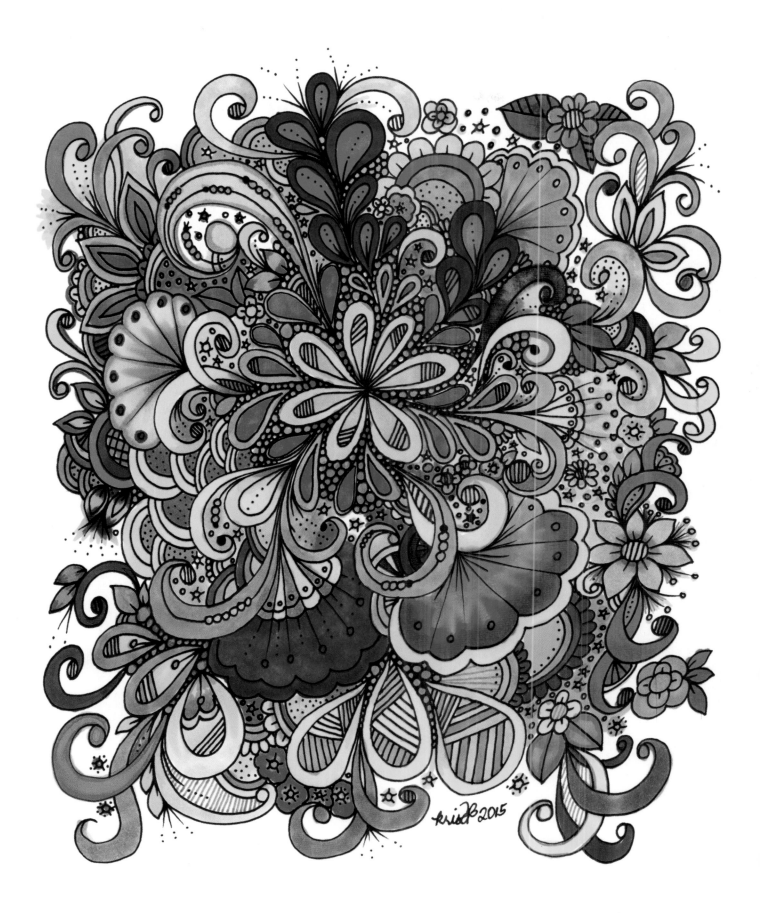

Botanical Beauty, page 71.
Markers (Blick, Copic). Color by Krisa Bousquet. 13

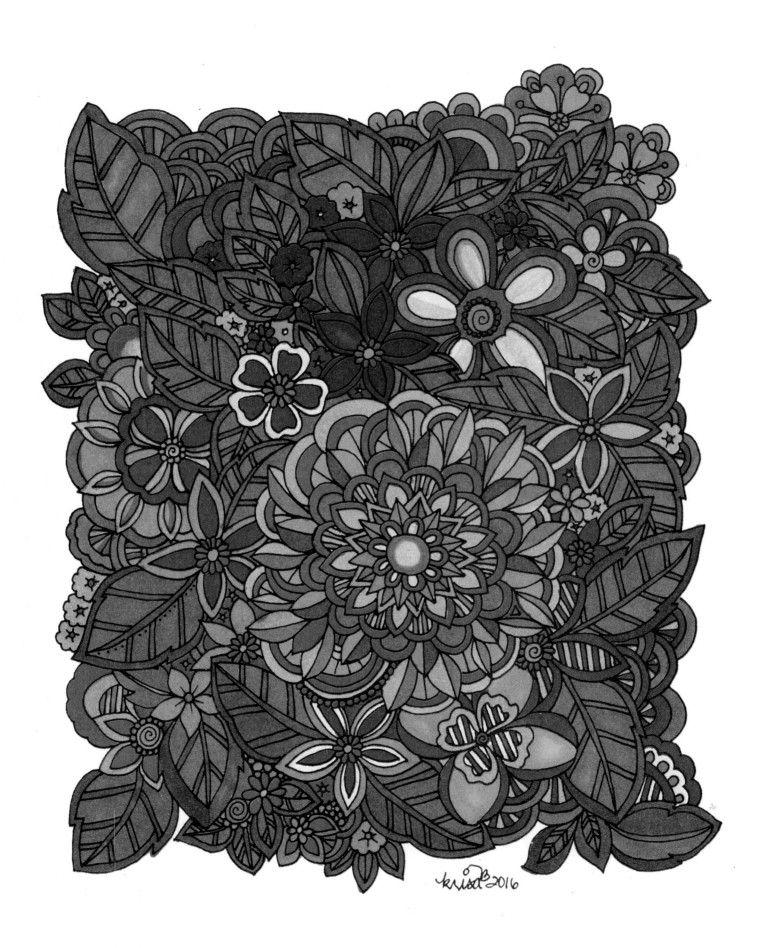

Rich Foliage, page 73.

Markers, gel pens. Color by Annelise Vuono.

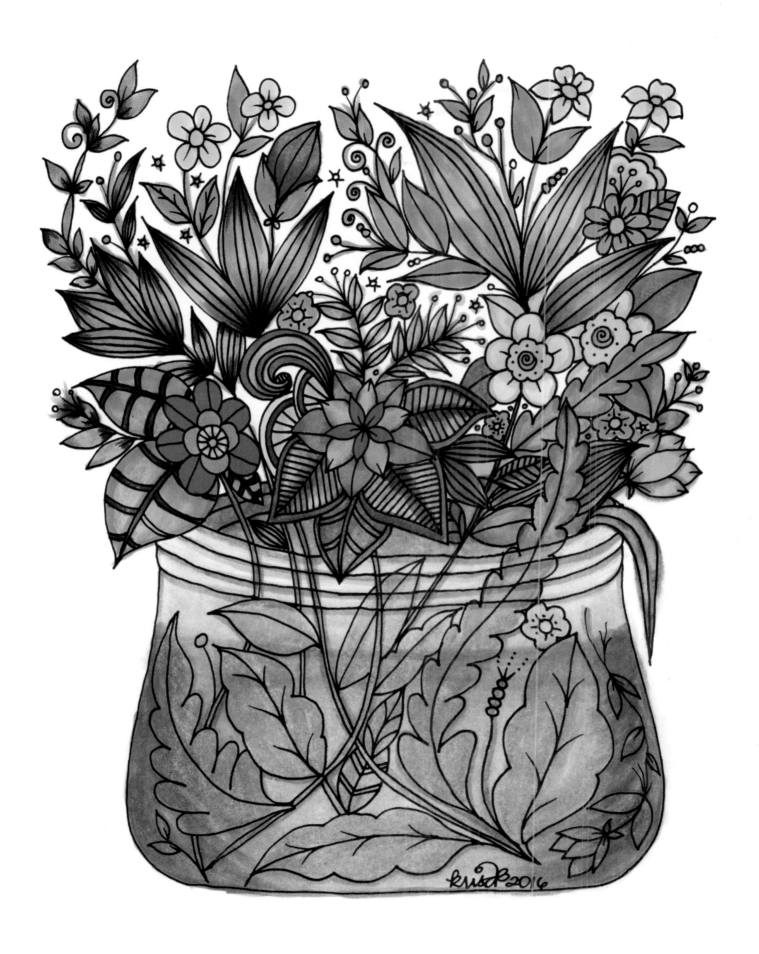

Sweet Bouquet, page 47.
Markers (Blick, Copic), colored pencils (Prismacolor). Color by Krisa Bousquet. 15

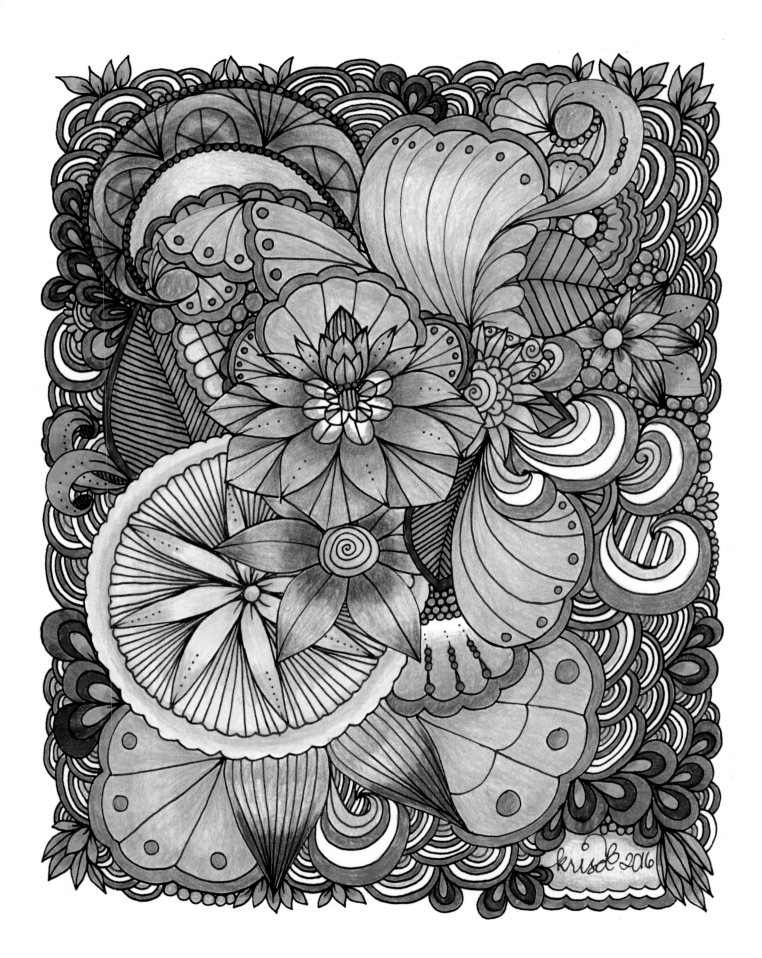

Beauty Swirl, page 53.

16 *Markers, colored pencils (Prismacolor). Color by Darla Tjelmeland.*

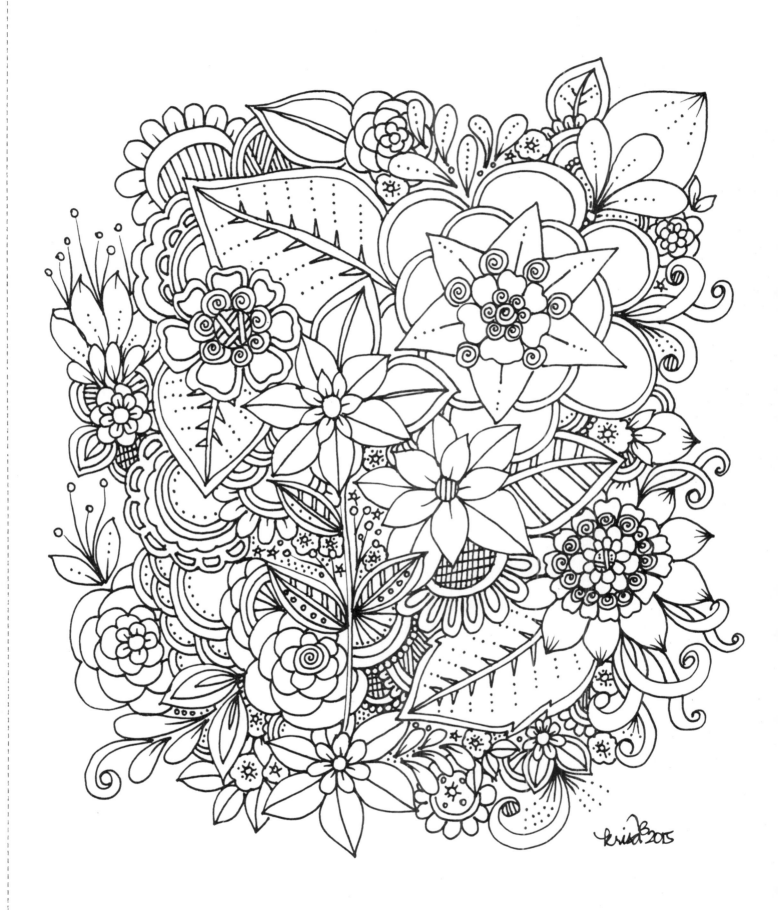

All the flowers of all the tomorrows
are in the seeds of today.

—Indian proverb

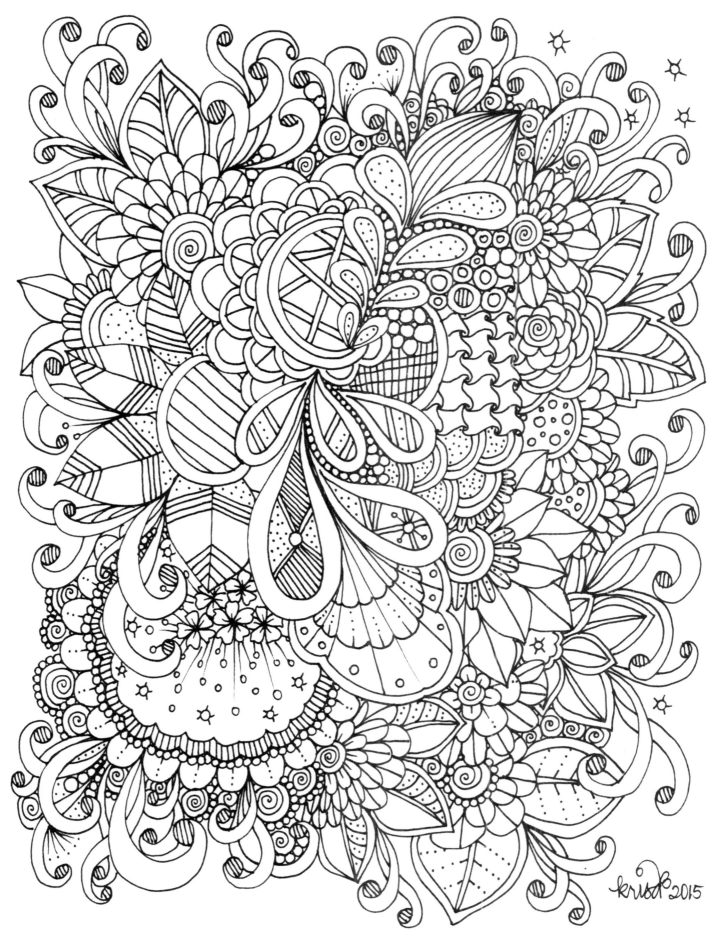

Adopt the pace of nature:
her secret is patience.

—Ralph Waldo Emerson

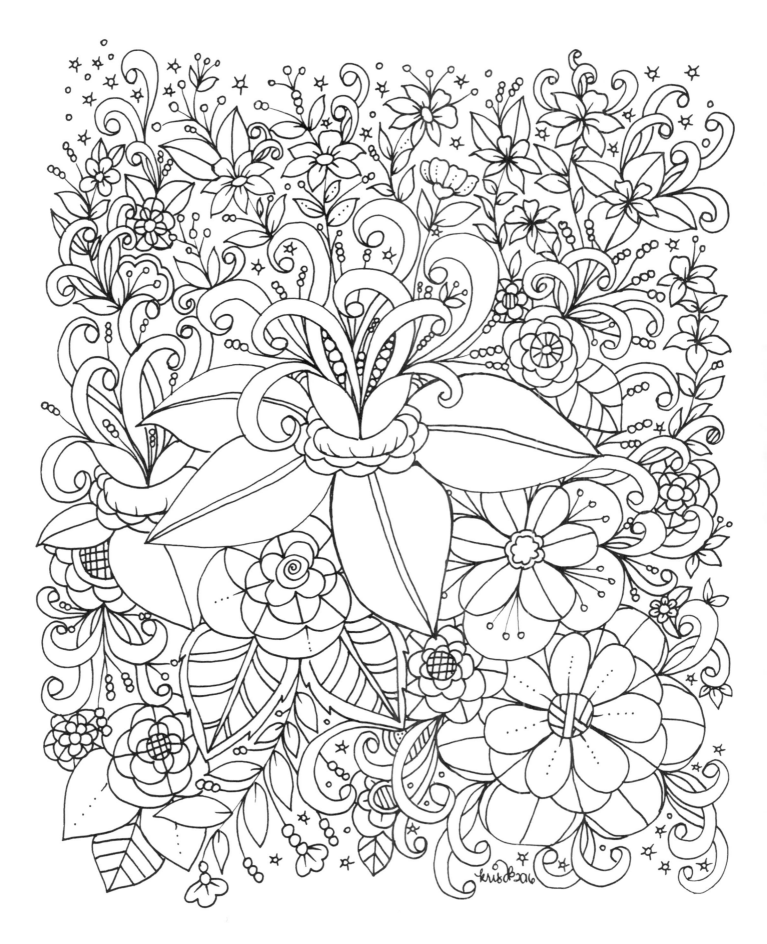

In my garden, after a rainfall,
you can faintly, yes, hear the
breaking of new blooms.

—Truman Capote

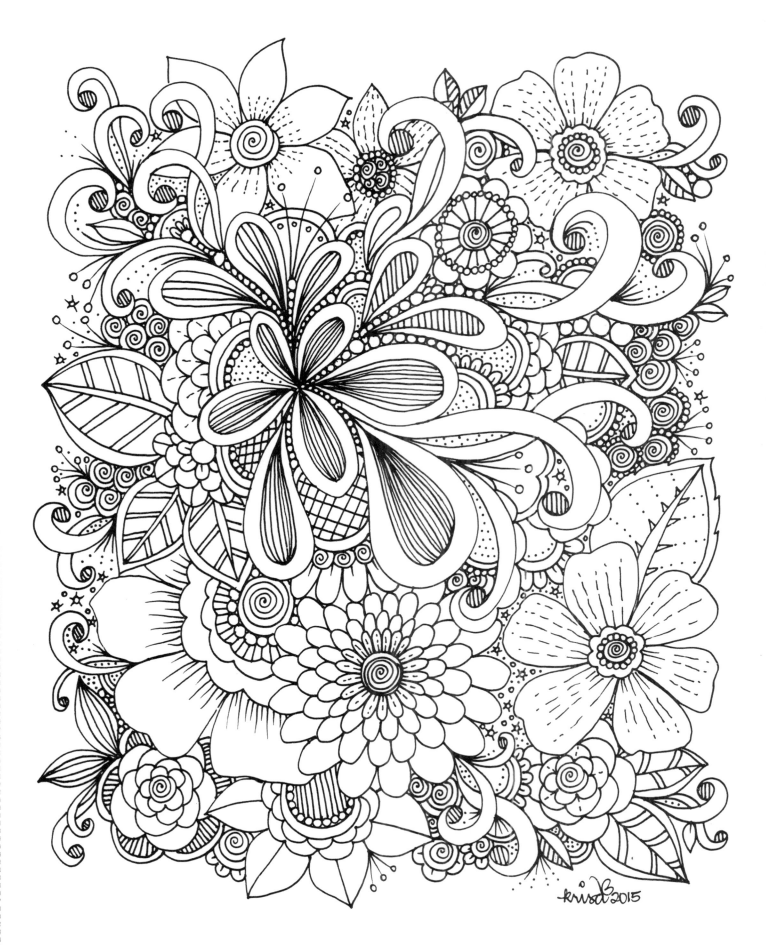

We may think we are nurturing our garden,
but of course it's our garden that
is really nurturing us.

—Jenny Uglow

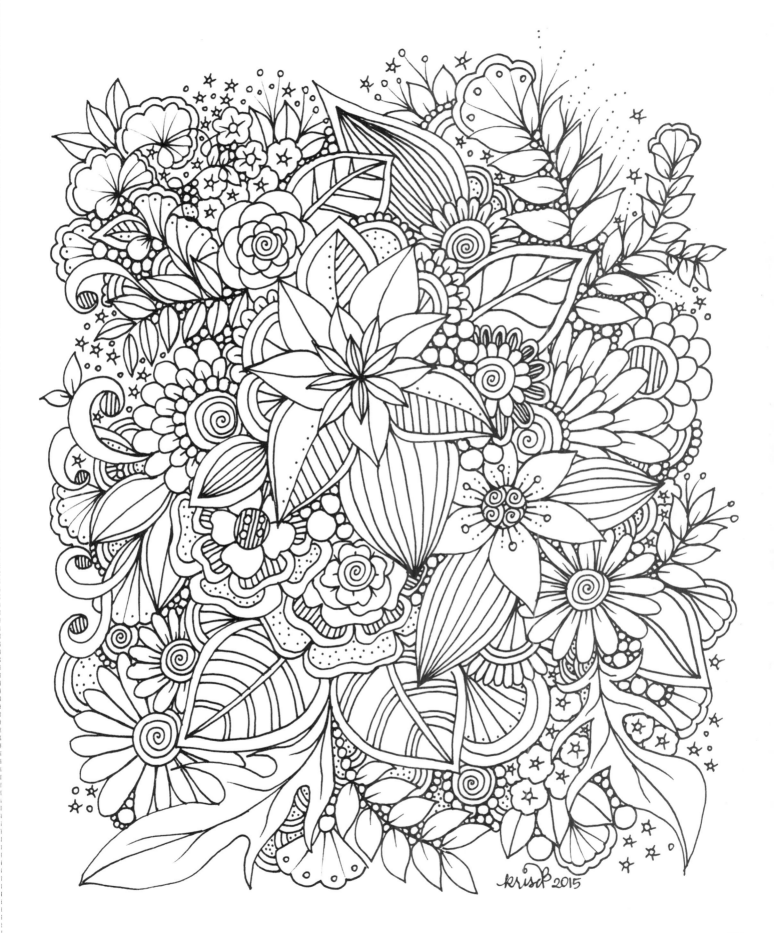

Rain will make the flowers grow.

—"A Little Fall of Rain," *Les Misérables*

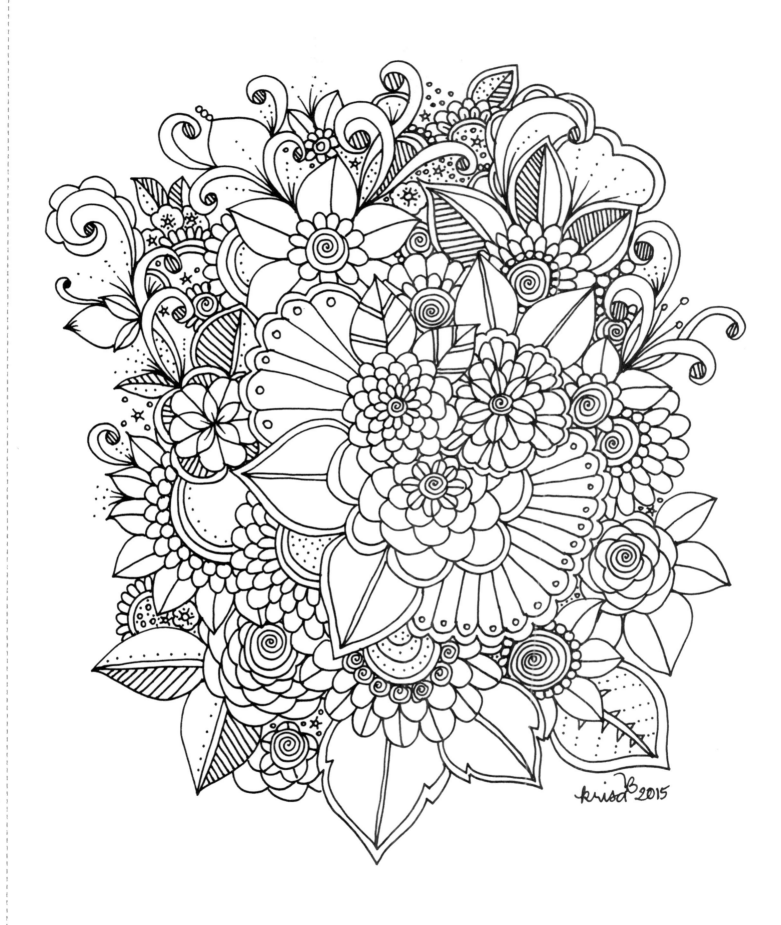

Flowers are the music of the ground,
from earth's lips spoken without sound.

—Edwin Curran

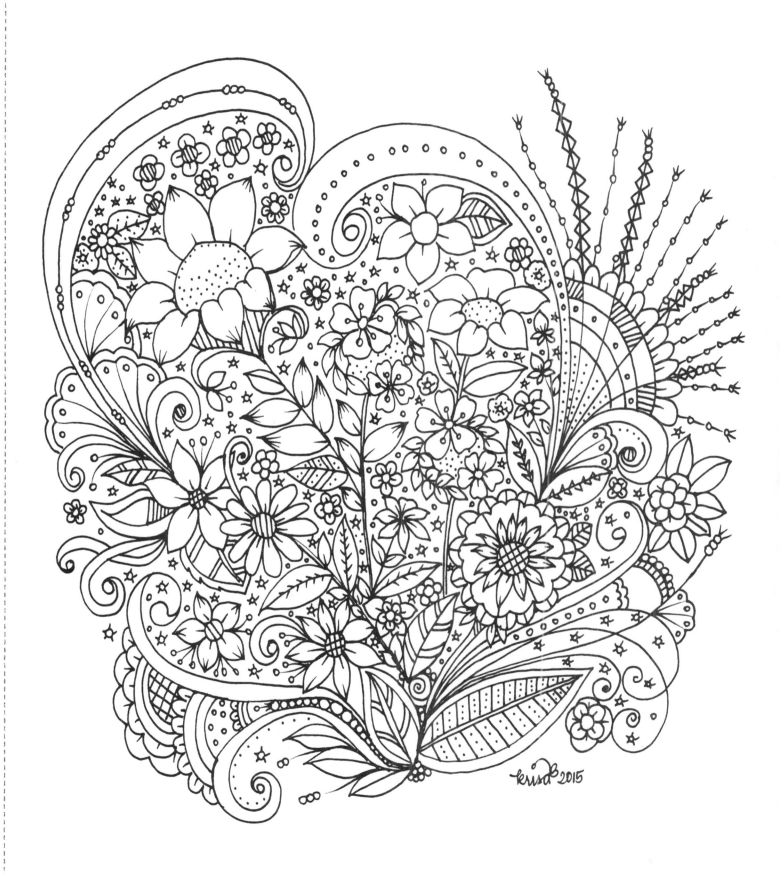

Let us dance in the sun,
wearing wild flowers in our hair.

—Susan Polis Schutz

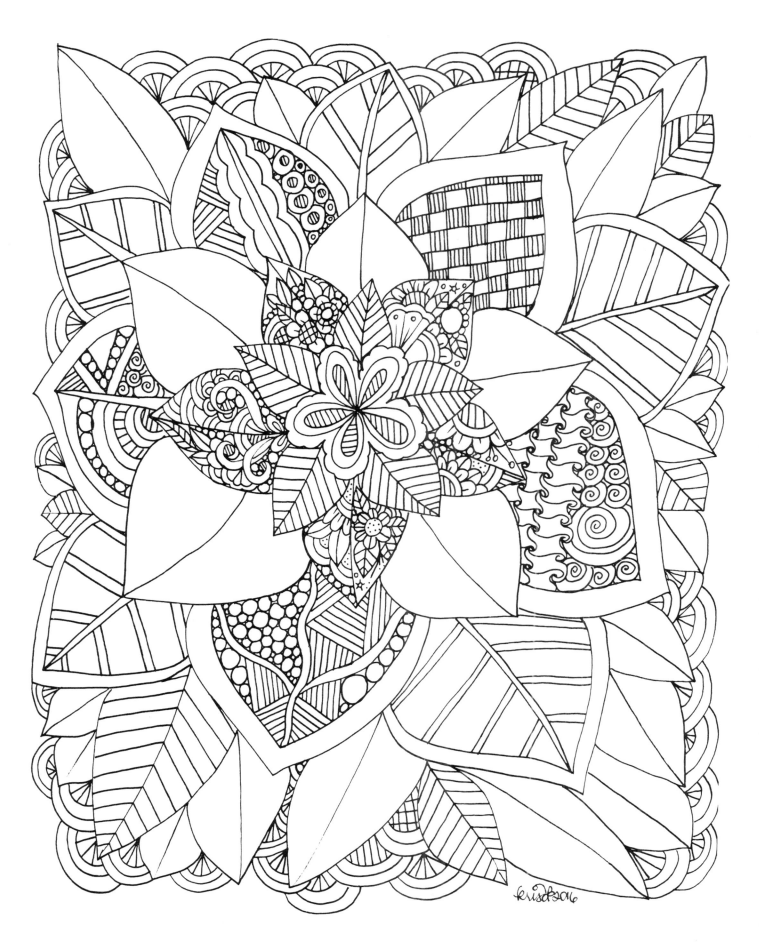

Love is a flower, you've got to let it grow.

—John Lennon, *Mind Games*

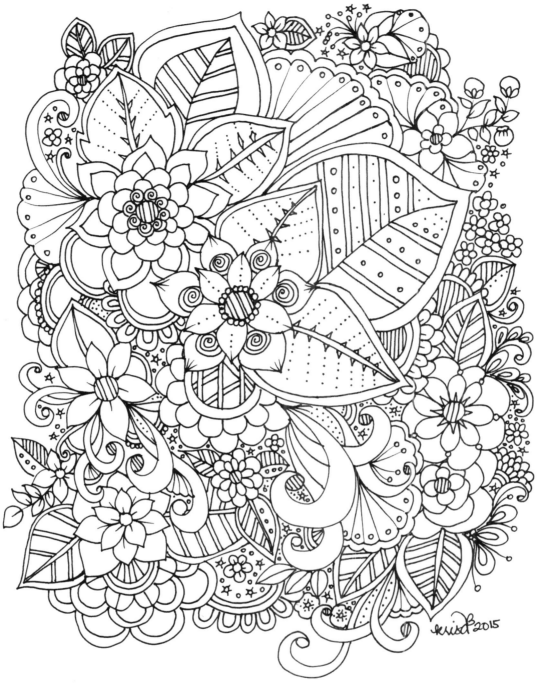

With green as the dominant color, every pop of
gold, blue, and red really stands out.

Normality is a paved road:
it's comfortable to walk, but
no flowers grow on it.

—Vincent van Gogh

Summer Blooms

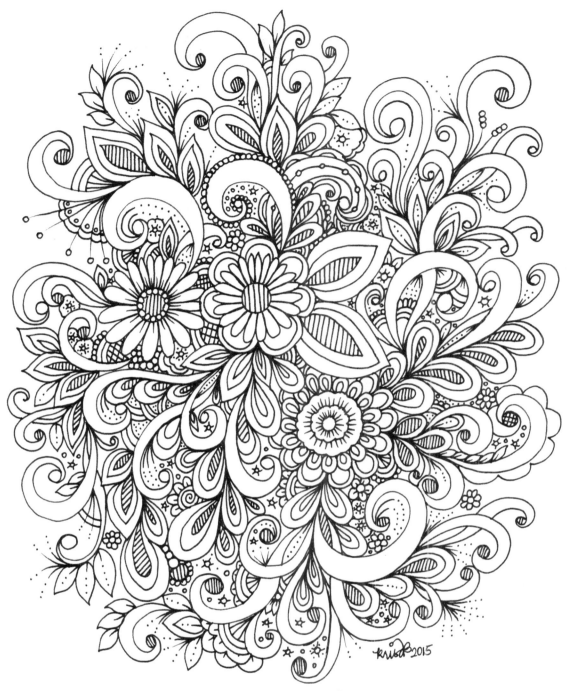

Try giving your piece an intense glow by
coloring in a soft-edged background.

For the beauty of the rose
we also water the thorns.

—African proverb

Petal Explosion

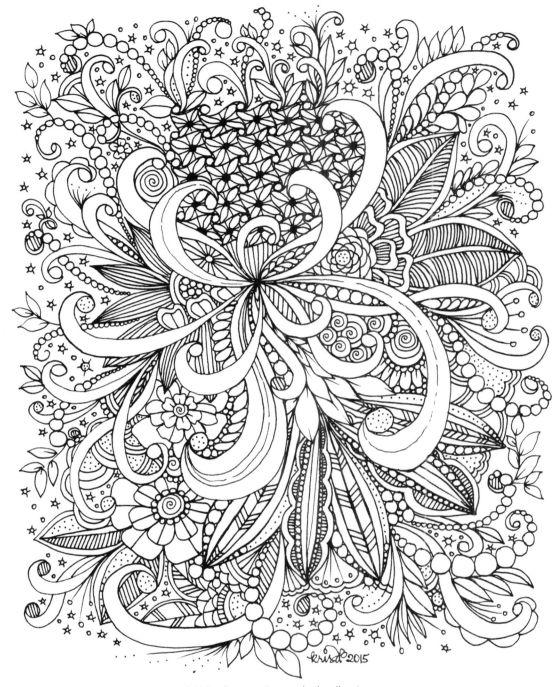

For a moody feel, use dark shades of colors like these.

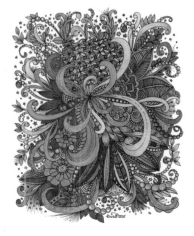

Raise your words, not your voice.
It is rain that grows flowers,
not thunder.

—Rumi

Flower Motion

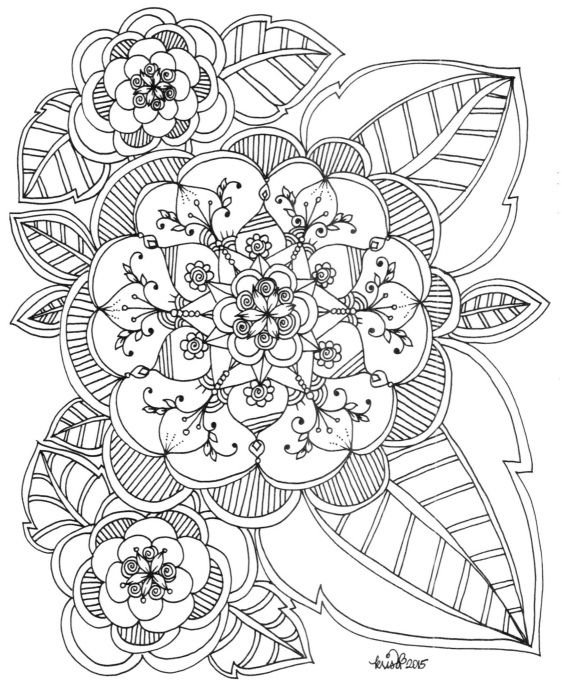

Don't forget about white space! You don't have to color every single area of a design to make an effective and gorgeous coloring.

It is up to you to see the beauty
of everyday things.

—Unknown

Flower Trio

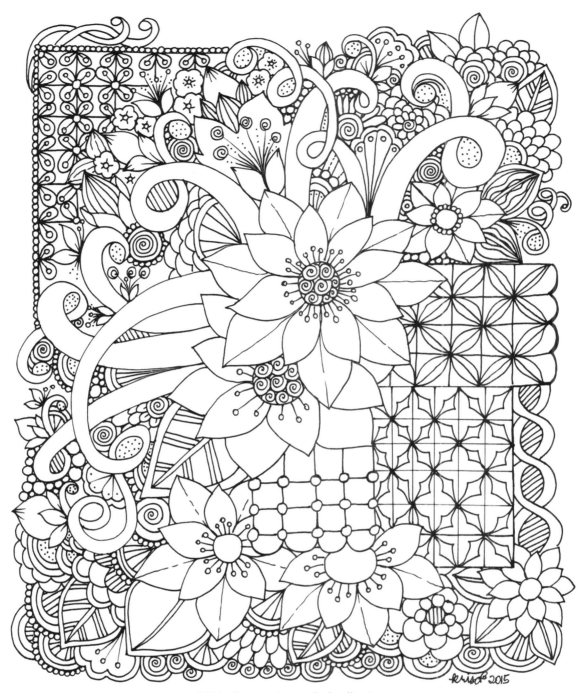

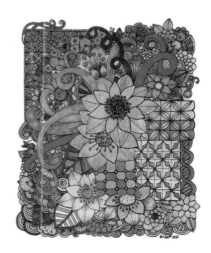

Secondary colors green, purple, and orange all go well together,
and you can mix in some shades of primary blue and yellow too.

With a few flowers in my garden,
half a dozen pictures and some books,
I live without envy.

—Lope de Vega

Garden Design

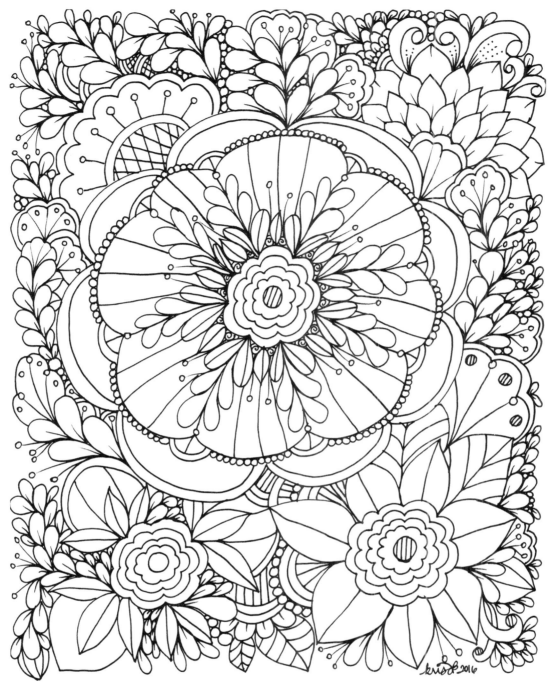

Faded pastels like these really give your piece a sunny, soft look.

She stopped and, closing her eyes,
took a deep breath of the flower-scented air....
For a moment she rediscovered the purpose of
her life. She was here on earth to grasp
the meaning of its wild enchantment.

—Boris Pasternak, *Doctor Zhivago*

Backyard Blooms

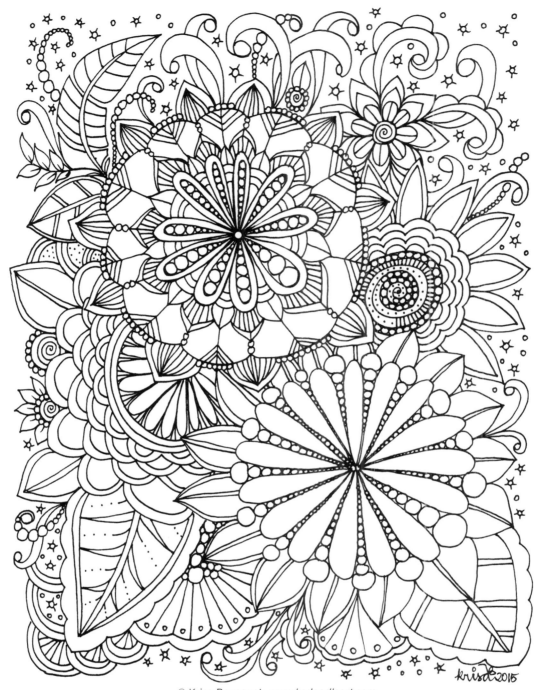

Vivid pink and red positively glow from this
background of muted, dark greens and blues.

Nature is painting for us,
day after day, pictures of infinite beauty,
if only we have the eyes to see them.

—John Ruskin

Flower Parade

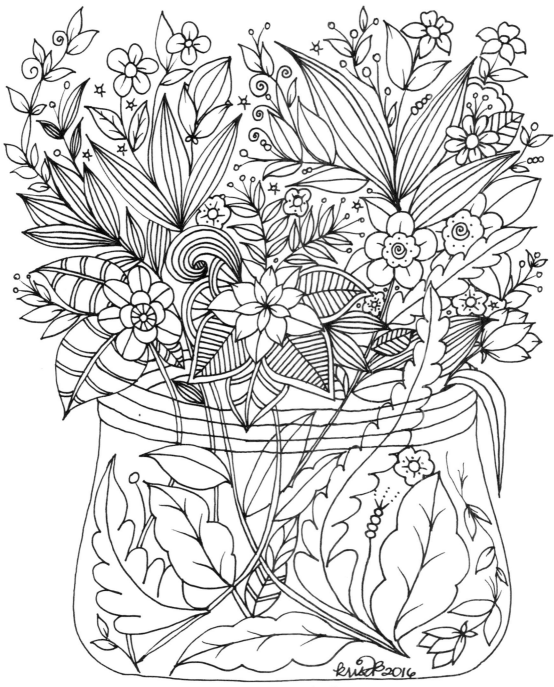

Water is not always plain old blue! Try giving your
water depth by mixing purple and aqua.

Be sure to wear some flowers in your hair.

—Scott McKenzie, *San Francisco*

Sweet Bouquet

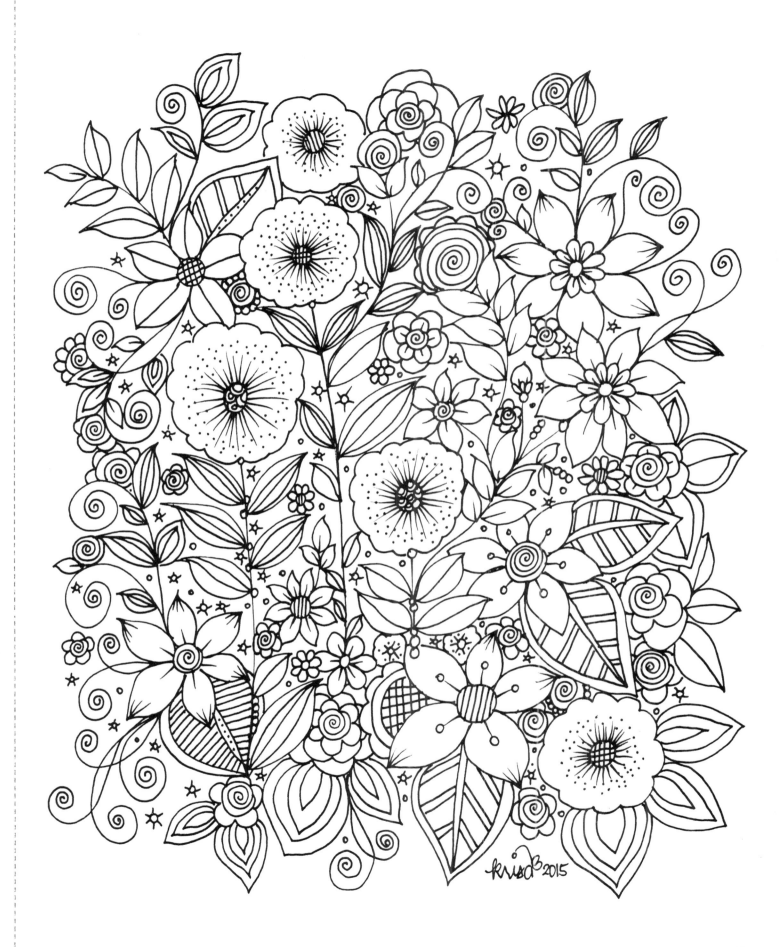

In the company of flowers
we know happiness. In the company of trees
we are able to think.

—John Stewart Collis

Poppies in the Mix

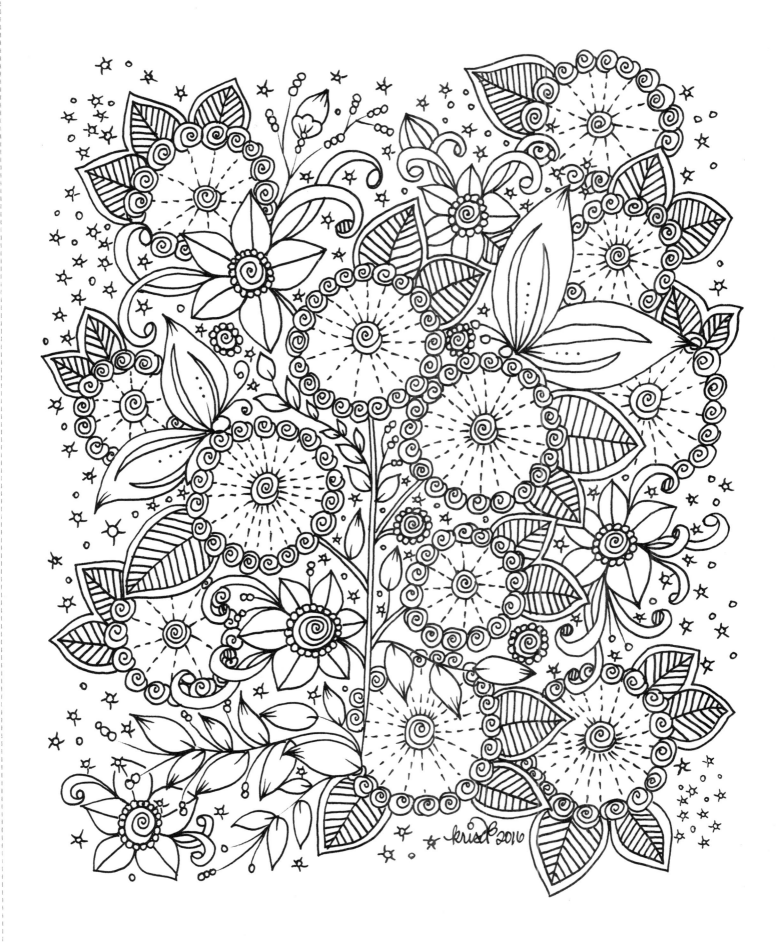

The glory of gardening: hands in the dirt,
head in the sun, heart with nature.

—Alfred Austin

Look at a tree, a flower, a plant.
Let your awareness rest upon it.
How still they are,
how deeply rooted in "just being."
Allow nature to teach you stillness.

—Eckhart Tolle

Beauty Swirl

Flowers always make people better, happier,
and more helpful; they are sunshine, food,
and medicine for the soul.

—Luther Burbank

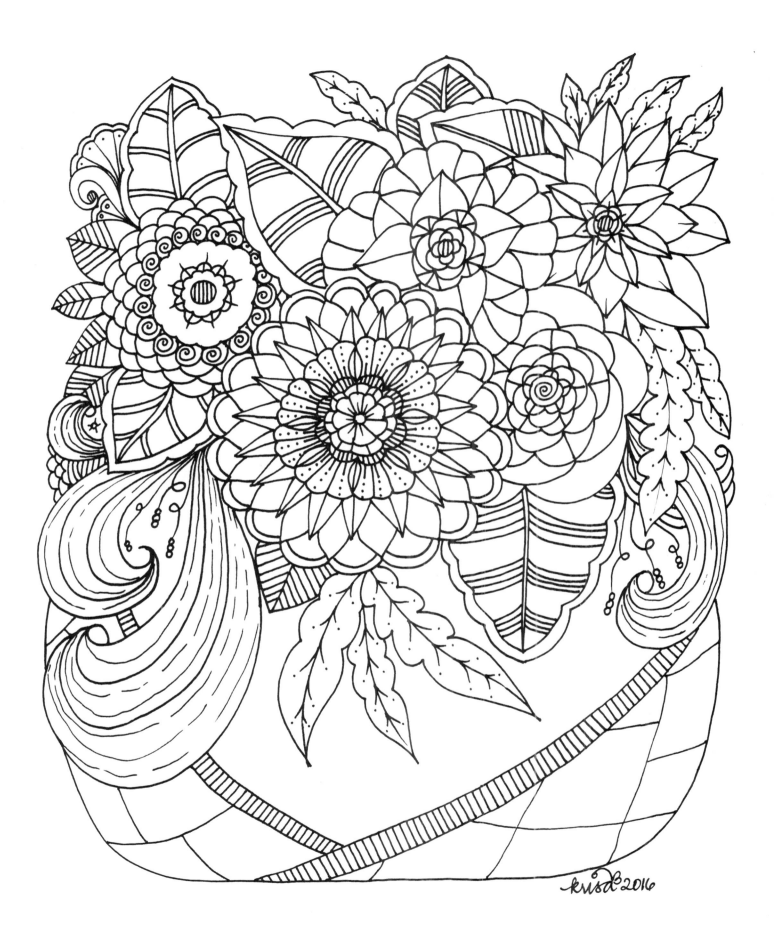

You can tell so much about a person by
the way they react to a single flower.

—Katrina Mayer

Basket o' Blooms

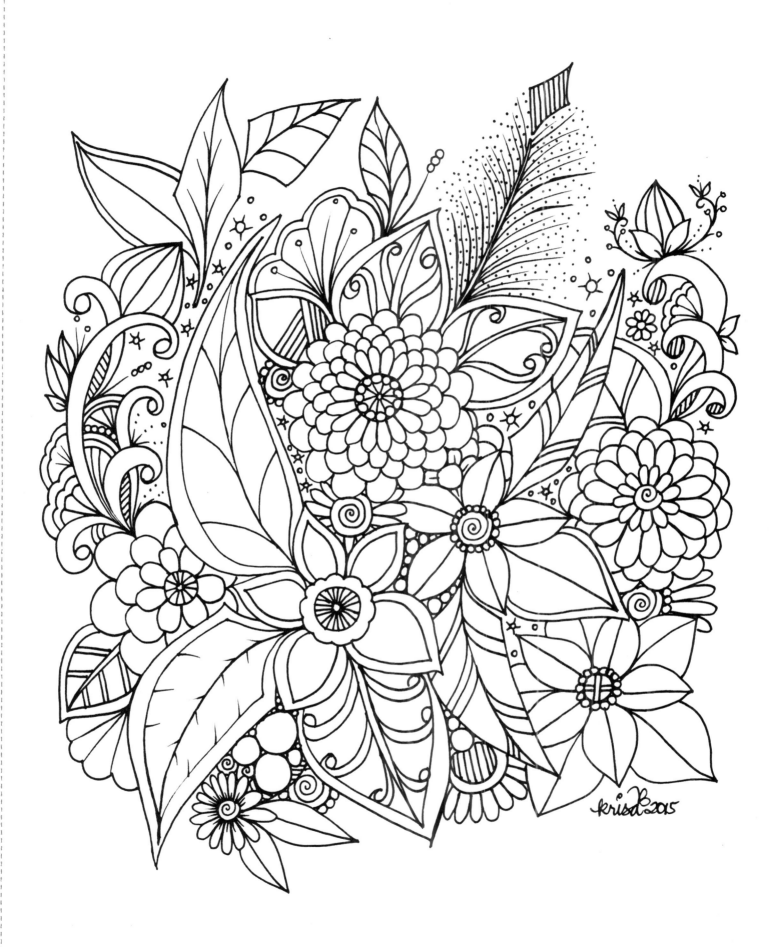

I grow plants for many reasons:
to please my eye or to please my soul,
to challenge the elements or to challenge
my patience, for novelty or for nostalgia,
but mostly for the joy in seeing them grow.

—David Hobson

Mum and Friends

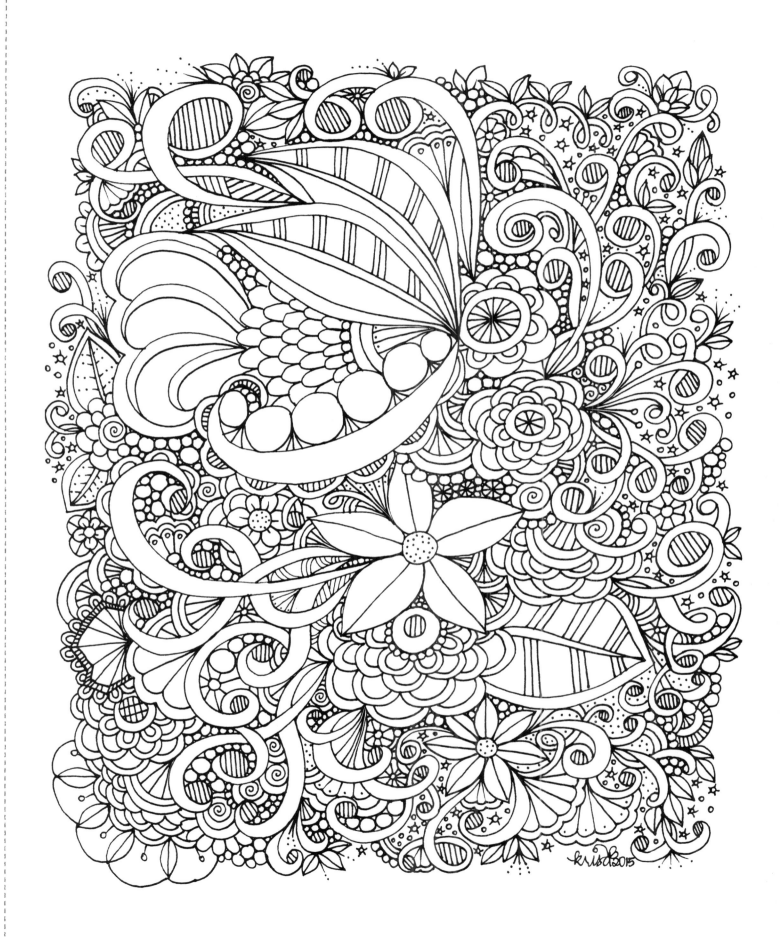

Mother Earth speaks to you
through every flower.

—Unknown

Tropical Flair

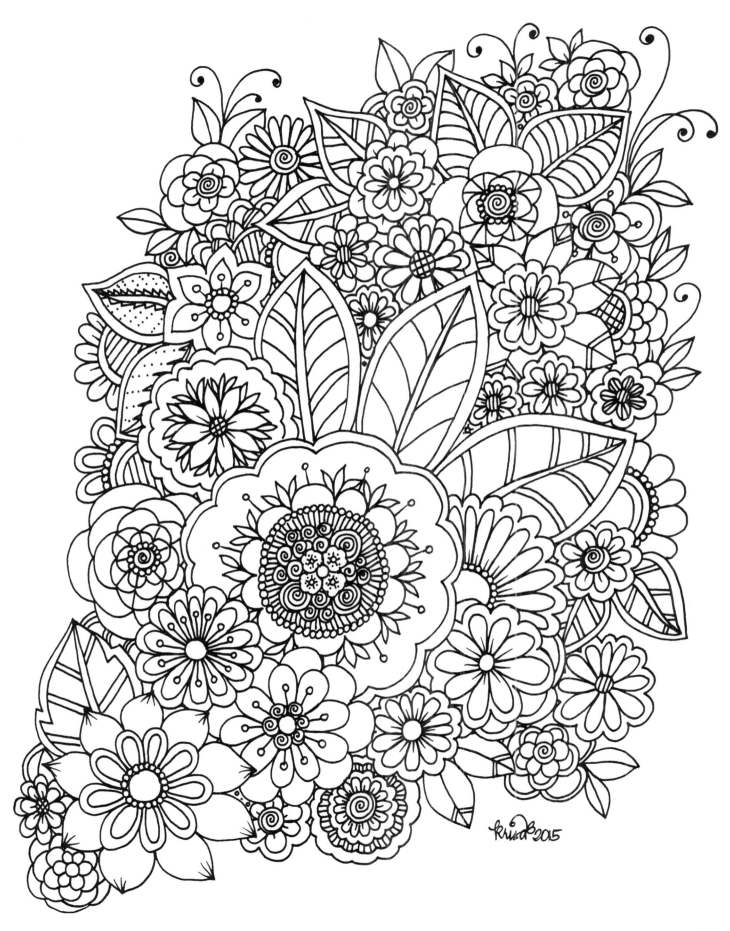

Where flowers bloom, so does hope.

—Lady Bird Johnson

Floral Bounty

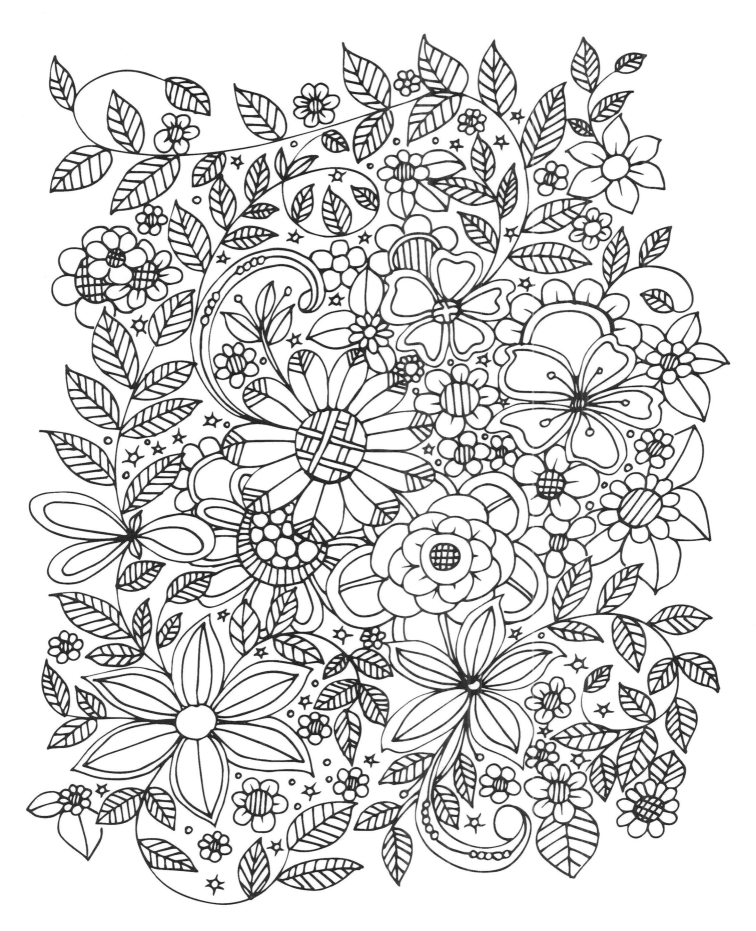

Every flower is a soul blossoming in nature.

—Gérard de Nerval

Spring Profusion

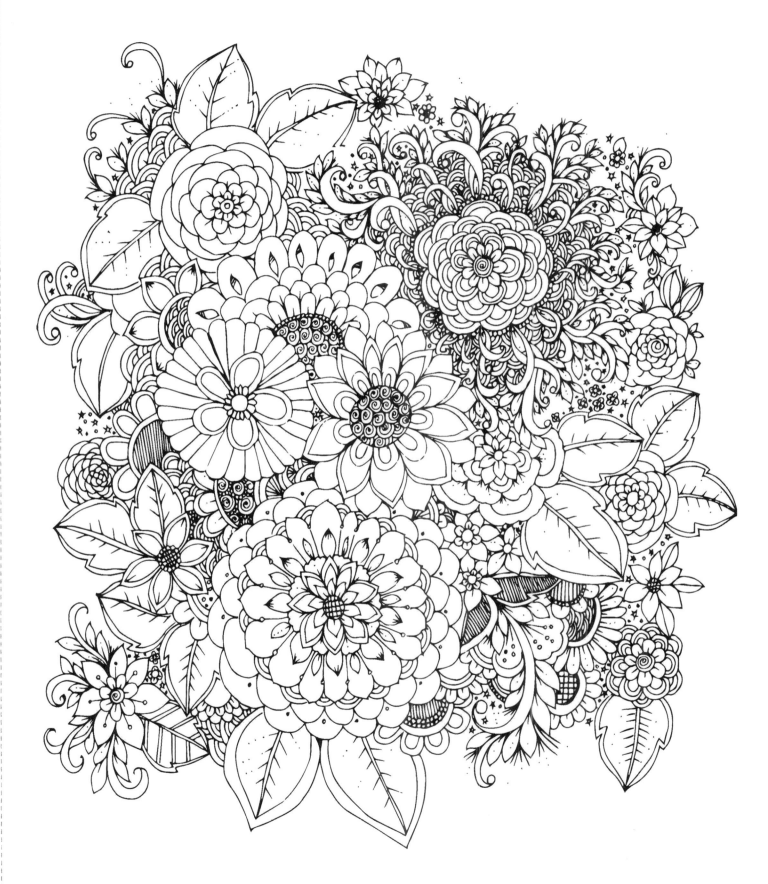

Nature is not a place to visit.
It is home.

—Gary Snyder

A flower's appeal is in its contradictions—
so delicate in form yet strong in fragrance,
so small in size yet big in beauty,
so short in life yet long on effect.

—Terri Guillemets

As I wander'd the forest,
the green leaves among, I heard a
wild flower singing a song.

—William Blake, *The Wild Flower's Song*

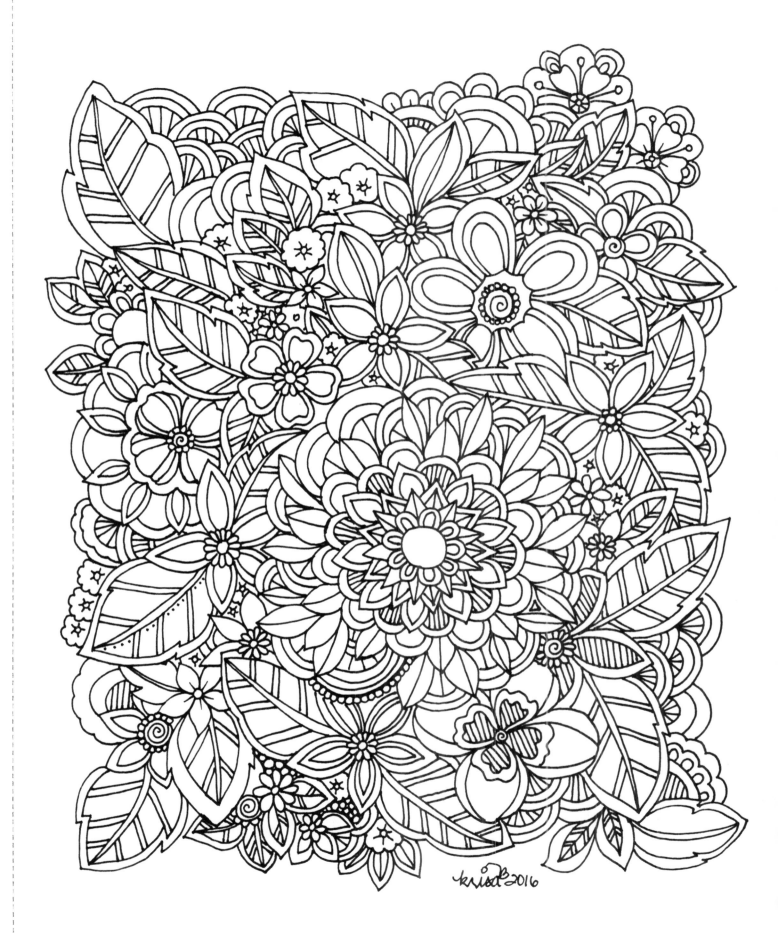

Flowers are heaven's masterpiece.

—Dorothy Parker

Rich Foliage

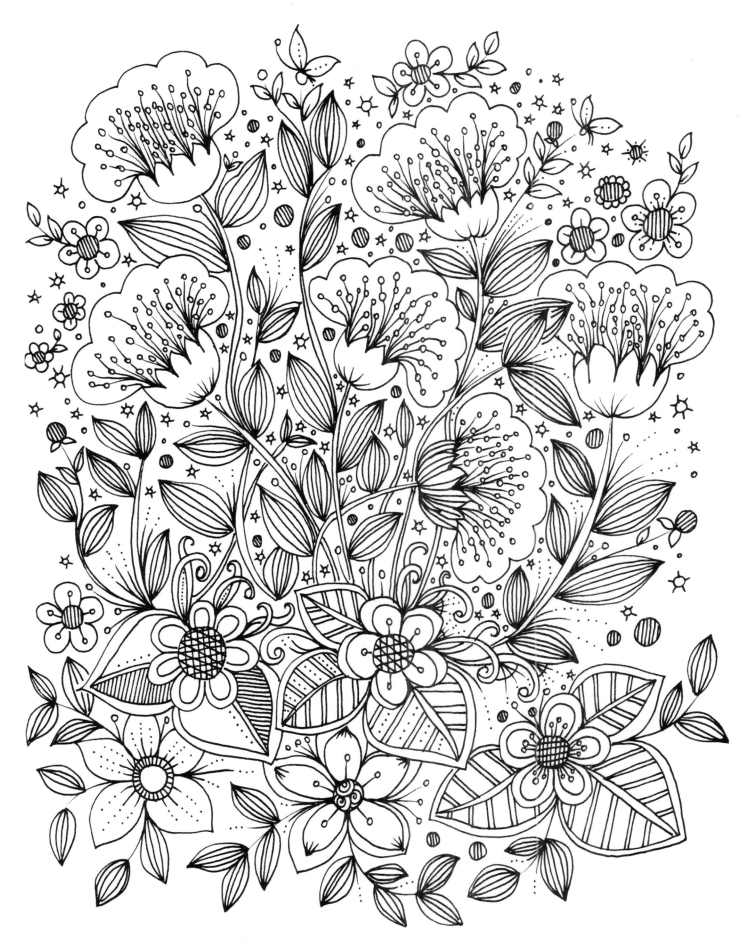

We belong amongst the wild flowers,
listening to the wind, or with
our toes dipped in the sea.

—Unknown

Feed your soul with positive energy
so you can grow and bloom
wherever life plants you.

—Katie Maslin

The first wild flower of the year
is like land after sea.

—Thomas Wentworth Higginson